International
Logos & Trademarks
VOL 5
01
5IVE

SUPON DESIGN GROUP

ISBN 0-06-018602-X

Library of Congress Catalog Card Number
00-092830

Distributed to the trade and art markets in the US by:
North Light Books, an imprint of F & W Publications, Inc.
1507 Dana Avenue
Cincinnati, Ohio 45207
Tel: 1-800-289-0963

Distributed throughout the rest of the world by:
HarperCollins International
10 East 53rd Street
New York, NY 10022-5299
Fax: 212-207-7654

Published by:
Madison Square Press
10 East 23rd Street
New York, New York 10010
Phone (212) 505-0950, Fax (212) 979-2207

International Logos and Trademarks 5
is a project of:
Supon Design Group
1730 M Street, NW
Suite 600
Washington, DC 20036

Printed in Hong Kong

Vol 5

International
Logos & Trademarks

Supon
Design
Group

5IVE

ACKNOWLEDGMENTS

Project & Creative Director:
Supon Phornirunlit

Art Director:
Tom Klinedinst

Jacket Designer:
Scott Livingston

Book Designers:
Melissa Yacuk, Tom Klinedinst

Managing Editor:
Supon Phornirunlit

Editor:
Clare James

Design Editors:
Supon Phornirunlit, Tom Klinedinst, Pum Mek-aroonreung

Production Manager:
Pavitra Pothpan

Associate Book Designers:
Daniel Adler, Jennifer Higgins, Linda Lam, Scott Boyer, Scott Livingston, Tara Guilday, Todd Lyda, Todd Metrokin

TABLE OF CONTENTS

INTRODUCTION

by Supon Phornirunlit

The swoosh. The apple. The peacock. The golden arches. It doesn't take a graphic designer to recognize the examples of logos that work. Even without a typographic identity to accompany them, marks such as these act as unmistakable and enduring company representations. They are understood instantly—without reading or thinking—and registered in a seemingly subconscious manner.

Few would disagree that this is the key to successful logo and trademark design. After all, even a toddler can catch sight of a looming "M" from the car window and recognize that the large yellow letter symbolizes McDonald's, without the ability to read the name—or the letter, for that matter.

The depth of the impression a logotype leaves on the mind of its public attests to its metaphoric role. Shapes, fruits, animals and letters act as symbols that promote recognition of a company (or product, person or event) through association. This process, often referred to as branding, aims to impress an indelible mark on the audience through the use of powerful—but often subtle—imagery.

More than stylistic symbols, however, logos and trademarks are also messages. As such, they not only represent a company, they communicate on its behalf. They convey who a company is and who it aspires to be. They hold meaning, substance and attitude. They capture emotion. They transcend language to communicate with distant countries or neighborhood children. In short, they encompass the entirety of an organization's vision within a graphic concept.

The logo's ability to communicate is fundamental to its success. Restaurants, stores, corporations, nonprofit organizations, even the media—all use

logos to promote recognition and provide instant information concerning their products, services, goals or traits. Just as importantly, though, a logo can only capture so many messages before it has attempted too much and become ineffectual. The key is to find a perfect balance.

COQUÍCO

™

The extension of a logo's communicative functions to stationery, signs, websites, even hats and T-shirts, forms a well-ordered system that we call the corporate identity. Taken together, these materials communicate a consistent and clear message to all who come in contact with them. They maintain a

Behind the Scenes

A profusion of high-technology venture companies and "dot com" businesses have launched themselves into today's society. Indeed, it seems that with the arrival of the millennium, there is a URL address for everything, a veritable www.a.com to www.z.com. But even beyond the technology industry—to traditional businesses, events and products as well—the demand for graphic identity design and development is widespread.

In such an environment, is it possible for logos and identities to be original anymore? Is every contemporary design merely a product of past influences and trends?

The judging process for *International Logos and Trademarks 5* afforded a unique opportunity to explore these questions. Like the four previous competitions, this year's entries epitomized the global aspect of the project, spanning a diversity of countries, industries and design disciplines.

It's true that with every edition the quality of submitted designs increases. As a result, so does the difficulty in selecting which small percentage should represent the best in the industry. Yet, of the thousands of entries received for each competition— from Salem to Slovenia, for software and shoes, and by international agencies and one-person operations—there are always some that make use of the same concepts. After five editions, this may no longer be a phenomenon, but it is certainly intriguing.

Renowned creative thinker Edward de Bono once said that, "Creativity involves breaking out of established patterns in order

to look at things in a different way." For designers, this surely seems an obvious statement, for the task of a designer is dependent upon an ability to communicate and connect in a striking or different fashion.

Then why is it that each year, so many designs fall into the same patterns? The swoosh, the stick figure and the "techno" typeface proliferated in Supon Design Group's mailbox this year. And while symbols, outlines and attractive type can be highly effective in conveying a message, a feeling or even the whole of a company's vision, they can also be highly predictable if used in the wrong way.

The logos—and applications of them—in this book succeed in achieving something more. At once refreshing, distinct, even surprising, they find a solution that goes beyond the obvious or the typical to offer a notion of the clients' values and philosophy. Some do successfully employ the swoosh or the human form, taking the concept far enough outside the "box" so that the idea, like a phoenix rising from a flame, again becomes a new and original concept.

Others explore different avenues and experience similar successes. Some triumph over the challenges posed by the use of humor in design, while some counter the high-tech craze with highly artistic or whimsical creations. Whatever the approach, it works. That is the power behind a logo. That is the power behind creativity. ■

company's image—and more importantly, its message—throughout all of its representations.

Embodying the impression it has on its publics, a corporate identity could be considered a company's foundation, the structure on which all future communication and interaction is built. An effective identity—that is easily recognized and visually appealing—can carry with it a great deal of credibility and influence.

An identity need not be attractive or pretty, but it must be simple and inviting. If it is too complex or unpleasant, it can hurt a company, and its reputation. It's not a matter of aesthetics, it's a matter of good sense.

Given these varied and challenging factors, each element of a logo design must be carefully considered—even scrutinized—early in the creative process. Does the typography, the color, the texture or even the size of the logo lend itself to successful transmission of messages or does it interfere with the intended communication? It is the strategic discovery of favorable answers for these questions that positions a logo as a strong, enduring and memorable image.

In the fifth edition of *International Logos and Trademarks* we have compiled the most effective, unique and diverse identities of the thousands that were submitted. Featured in the next 173 pages are the best of the best. These pieces not only represent their clients, but the talent and insight of the designers who created them. Such creative and fearless individuals have succeeded with clever and appropriate logos that "fit." This intuitive ability—to provide a "fitting" solution—makes each of these designers true winners.

Just like the four previous editions of *International Logos and Trademarks*, this book would not have been possible without the enthusiastic response of the entrants. To each person who contributed a design, I am grateful, not only for the creativity, hard work and skill evident in each one, but for the willingness to share these qualities. Every year, I am overwhelmed by projects that are rich in

BrandHarvest

spirit and originality, and reawakened by the fresh per-
spectives held within each one. Not only does this
make the process of selecting winners a painstaking
one—it inspires me to begin thinking
about the next edition.

Included among the winning
pieces are outstanding corporate,
product and event logos, stationery,
packaging and identity campaigns
from a dozen countries around the
world. While the logos and trade-
marks featured represent a diversity
of companies, organizations, events

and businesses, they share attributes as well. They
serve as effective and compelling means of commu-
nication. They surpass the novelty of a trend or
"look." And they combine substance
and quality to achieve a result that is
simple, clear and timeless.

With that, I offer my congratula-
tions to all of the designers
featured here, and I encourage
those who have shared their
work to continue to do so for future
volumes of *International Logos and
Trademarks.* ■

Supon Phornirunlit ■ Creative Director ■ Supon Design Group

*A prodigy of design schools in Thailand, Japan and the U.S., Supon excels in establishing the
vision behind high-profile design projects. He is skilled in the creation and implementation of
promotional and marketing concepts, and has spearheaded the design and development of
many successful campaigns, including Olympic sponsorship by both IBM and Coca-Cola and
recruitment for The George Washington University.*

*Supon and his team have earned more than 1,000 industry awards, including Gold Awards and
Best of Show honors in virtually every design category, including print, new media, advertising,
broadcast, product packaging and interior design.*

*Supon Design Group offers a full range of design services to such notable clients as the
Department of Energy, The Points of Light Foundation, World Bank, the Associated Press and the
U.S. Postal Service. In May, 1999, Supon Design Group merged with Multi-Media Holdings, Inc.
(MHI), joining 22 other companies in offering its clients truly integrated marketing solutions.*

*Supon Design Group's work and profile have appeared in international publications including Small Business News Washington,
Novum, Studio, GM, art4d, Asia, Inc., Graphis, Communication Arts, Print, Step-by-Step and HOW.*

*Supon has served on the board of directors of the Art Directors Club of Metropolitan Washington and the Broadcast Designers'
Association. He holds a B.A. in Advertising Design from the International School of Design. He regularly speaks and judges at
various organizations and schools.*

COMMENTARY

by Bill Gardner

One of the designer's most gratifying rewards is finding the surprise element or twist in a visual phrase that stops us dead in our tracks. Knowing when enough is enough. Having the sense to listen to ourselves. Discovering virgin visuals because we are wise enough to travel beyond the bone yards of expected solutions. These are the moments in which brilliance dwells.

None of this wisdom seems to be available in design writing or as part of a graphic arts curriculum. Rather, it tends to be absorbed by osmosis during a life spent in areas alien to design, reading everything from comic books to mythology and cookbooks to theology. The best designers I have ever worked with loved design above all other activities, but they did not allow design to constitute the total depth of their interests.

Long before they learned to cajole a shy image from a barren page, they were insatiable absorbers of

every spirit. They rode bulls and rebuilt cars; they rowed crew and danced in the streets; they performed magic and studied Latin. The deeper they were, the better they were. After all, we need only predict the depth of a designer to predict the depth of his or her design.

When designing a logo, we rely on our ability to make visual connections that will be correctly interpreted by the consumer. A design without substance may serve as no more than a clever decoration. But a logo with depth—relying on consumer interaction to

complete an association—has already created a sense of ownership through participation.

Like a toy that is too simplistic, we quickly discard or lose interest in an identity without depth. A great veneer cannot disguise a one-dimensional logo. A healthy, robust identity contains at least three levels of symbolism. Each level speaks to no one, but lays itself open for deciphering and interpretation. It compels the consumer to contend with a message.

In turn, each viewer will peel back the layers of significance in a unique fashion. Some will understand all layers immediately; to others the logo will reveal itself more slowly; some may even unearth symbology that escaped the designers themselves. Regardless, these innate messages force the consumer to have a relationship with the logo.

So where can we find these layers of substance?

Here is a smattering of some of the resources we consult when initially researching an identity. Some seem obvious, and others are less so. Each forces us to investigate a potential logo from enough directions that it starts to take on its own dimensionality.

Lexicons (a tip from Michael Cronan): I visit Lexical FreeNet (www.lexfn.com) on a daily basis for one inquiry or another. Type any word, and it will return a massive list of not only synonyms and antonyms, but triggers, rhymes, generalizations, connections and more. Type two words and find common links between them. What an incredible tool.

Latin dictionary: It sits next to my computer and looks like a small Bible. It is. Latin is the base of romance languages, including English, so any word can be traced to its foundation. This expands the understanding of root words and provides a deeper appreciation for words than that which is obtained from Webster's definitions.

Mythology: It is the foundation of storytelling. Use the tales we recall from childhood to retell a story. The site (www.webcom.com/shownet/bulfinch/) is a great search tool for words or concepts that relate to mythology. Search Aesop's Fables, fairy tales, history or any other parable which extols the virtues of a client. Visually, a story takes half the time to tell when we already know it.

Animorphics: In a similar vein, a client may have virtues or characteristics of an animal or mythological creature. It may be "as fast as..." or "as big as..." or "as clever as..." Using transference, a logo may imply a much deeper symbology because the consumer is already familiar with the imbued characteristics.

Picture search: Take a look at the Lycos advanced search feature, for pictures only. Type a search word and stand back. Any photo on any site with that word in its name will appear, including drawings, logos, graphics and anything else with a vague association. Unexpected discoveries will have the greatest impact.

eBay: A tremendous online resource for a reference picture of anything. What does the armature on a microscope look like? What is the profile of an anvil? What is the stitching on a tapestry like? Where

can I find reference for a Ouija board? eBay is also a prop hunter's dream for photo shoots.

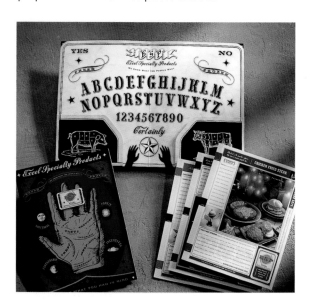

Posters: www.allposters.com is one of many poster sites that can prompt ideas. Look up any artist, period, subject matter or concept. What would a WPA artist have done? Deco or Constructivist? What kind of palette would he have invoked?

Above all else, we must read. Read outside of the design field. Bury ourselves in that which does not matter. For it is there that we will make the connection that will stun the viewer, and it is there that we will reach our epiphany. ■

Bill Gardner ■ President ■ Gardner Design

Bill Gardner attended Kansas State University and Wichita State University, where he earned both a B.B.A. in Marketing and a B.F.A. in Design. As president of Gardner Design, a brand development and graphic design firm, his work has produced effective and award winning results for clients such as Learjet, Thermos/Nissan, Pizza Hut, Coleman Outdoor, Excel/Cargill Corporation and others.

*Gardner Design's work has appeared in or been featured by **Communication Arts, Print, Graphis, New York Art Directors, Step By Step, HOW,** the Museum of Modern Art and other national and international design exhibitions. Bill's works and writings regarding corporate identity and three-dimensional design have been published in numerous books and periodicals.*

He is the founding president of The American Institute of Graphic Arts Wichita chapter and serves nationally on various policy committees. Bill is also the founder of LogoLounge.com and can be reached at www.GardnerDesign.net.

VOL **5**

International
Logos & Trademarks

JUDGES CHOICE

JUDGES' CHOICE

Client: ChildAlert / Design Firm: RBMM

Client:
ChildAlert
Nature of Business:
Crib monitors
Design Firm:
RBMM
Designer:
Shazne Washburn

Client:
YPO Eurodisney
Nature of Business:
Young Presidents' Organization
Design Firm:
RBMM
Designer:
Dan Birlew

JUDGES' CHOICE

Client: Brown Shoe Company / Design Firm: Kiku Obata & Company

BROWN SHOE

Client:
Brown Shoe Company
Nature of Business:
Shoe manufacture
and distribution
Design Firm:
Kiku Obata & Company
Designers:
Scott Gericke, Amy Knopf,
Joe Floresca, Jennifer Baldwin

Client:
West Associates
Nature of Business:
Plastic surgery
Design Firm:
RBMM
Designer:
Dan Birlew

JUDGES' CHOICE
Client: Club Café Moosis / Design Firm: Neville Smith Graphic Design

Client:
Club Café Moosis
Nature of Business:
Café and bar
Design Firm:
Neville Smith Graphic Design
Art Director:
Neville Smith
Designer:
Neville Smith
Illustrator:
Neville Smith

Client:
Land of Oz
Nature of Business:
Boarding kennels
Design Firm:
Gardner Design
Art Director:
Travis Brown
Designer:
Travis Brown

JUDGES' CHOICE

Client: Mirko Hocevar, Ljubljana / Design Firm: KROG

Client:
Mirko Hocevar, Ljubljana
Nature of Business:
Interior joiner
Design Firm:
KROG
Art Director:
Edi Berk
Designer:
Edi Berk

Client:
Safetemp
Nature of Business:
Airplane de-icer
Design Firm:
Gardner Design
Art Director:
Chris Parks
Designer:
Chris Parks

JUDGES' CHOICE

Client: Le Groupe Dance Lab / Design Firm: Parable Communications

Client:
Le Groupe Dance Lab
Nature of Business:
Experimental dance event
Design Firm:
Parable Communications
Art Director:
David Craib
Designers:
David Craib, Peter Watts

Client:
HealthProm
Nature of Business:
Medical aid for countries in
the former Soviet Union
Design Firm:
Tor Pettersen & Partners
Art Director:
Tor Pettersen
Designers:
Tor Pettersen, Joann Weedon
Illustrator:
Alex Jessop

JUDGES' CHOICE

Client: Pat Taylor Inc. / Design Firm: Pat Taylor Inc.

Client:
Pat Taylor Inc.
Nature of Business:
Graphic design
Design Firm:
Pat Taylor Inc.
Art Director:
Pat Taylor
Designer:
Pat Taylor

More

KB
99

Bruce Karatz, Chairman and Chief Executive Officer

FEBRUARY 10, 2000

To Our Shareholders,

This morning I listened to yet another commentator talking about America Online's proposed acquisition of Time Warner – a merger that's dominated the business headlines for the past month.

I share the belief that this deal is perhaps the most significant in recent American history. It institutionalizes the power of the Internet, and represents the ascendancy of "new media" over "old media." And if history is any judge, it's just the tip of the iceberg.

There could be no better time for me to share my thoughts with you on how Kaufman and Broad will be a part of this new world.

Client:
Kaufman and Broad
Home Corporation
Nature of Business:
Residential real estate
Design Firm:
Louey/Rubino Design Group
Art Director:
Robert Louey
Designer:
Alex Chao
Photographer:
Victor John Penner

More leadership

the process of homebuilding

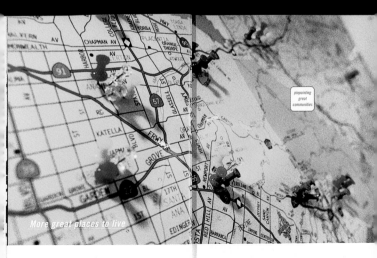

*pinpointing
great
communities*

More great places to live

Before we sell our first home we know we'll be successful – because we've chosen the right *location* for a new community. Our in-depth *community mapping* process factors in our exclusive homebuyer surveys, as well as local infrastructure, schools, major employers, cultural attractions and a host of other criteria. As a result, we're building our homes where our customers want to live.

FRUEAUFVILLAGE
◇HIGHINTHE
AUSTRALIAN
ALPS
THE HEART OF FALLS CREEK

INFALLSCREEKSKIRESORTAUNIQUEATMOSPHEREWI

FIVE LUXURY BUILDINGS SENSUOUS & RAW;
INTIMATE, DESIGNED WITH ARCHITECTURAL
INTEGRITY & STYLE. AN ECO-VILLAGE ESCAPE,
WITH SPECTACULAR SCENERY & SKIING TERRAIN.

CHALET**BLANCO** FRUEAUF**CENTRAL** CHALET**GE**
CHALET**INVERNO**neve CHALET**Scholtes**

CINEMA**GLO** • BAR/CAFE**MILCH** • SEMINAR AND CONFERENCE CENTRE

MT McKAY
THE SKIING MECCA WILL FINALLY BE OPEN TO
FALLS CREEK SKIERS. SEASON 2000 WILL BE
THE FIRST TIME DOWNHILL SKIERS + BOARDERS
WILL BE ABLE TO EXPERIENCE AUSTRALIA'S
STEEPEST AND LONGEST RUNS

JUDGES' CHOICE

Client: Le Groupe Dance Lab / Design Firm: Parable Communications

Client:
Le Groupe Dance Lab
Nature of Business:
Experimental dance event
Design Firm:
Parable Communications
Art Director:
David Craib
Designer:
David Craib
Illustrator:
David Craib
Photographer:
Jim Cochrane

International
Logos & Trademarks

MERIT

Client:
Anastasia Cosmetics
Nature of Business:
Cosmetics
Design Firm:
BIRD Design
Designer:
Peter King Robbins

Client:
Allen's Excavating
Nature of Business:
Excavation
Design Firm:
Gardner Design
Art Director:
Chris Parks
Designer:
Chris Parks

Client:
Austin Gym
Nature of Business:
Exercise facility
Design Firm:
RBMM
Designer:
Shazne Washburn

apartment**zero**

406 7th street, nw
washington, dc 20004
t. 202.828.4567
f. 202.828.4069

www.apartmentzero.com

apartment**zero**

406 7th street, nw
washington, dc 20004

CHRISTOPHER RALSTON

apartment**zero**

406 7th street, nw
washington, dc 20004
t. 202.828.4567
f. 202.828.4069
www.apartmentzero.com

Client:
Apartment Zero
Nature of Business:
Contemporary Furniture
and Accessories
Design Firm:
Supon Design Group
Art Director:
Supon Phornirunlit
Designer:
Pum Mek-aroonreung
Illustrator:
Pum Mek-aroonreung

Client:
Brad Bachman Homes Inc.
Nature of Business:
Home construction near bodies
of water
Design Firm:
Insight Design Communications
Art Directors:
Sherrie Holdeman,
Tracy Holdeman
Designers:
Sherrie Holdeman,
Tracy Holdeman
Illustrators:
Sherrie Holdeman,
Tracy Holdeman

Client:
Barrington
Nature of Business:
Business and
engineering solutions
Art Director:
Aram Youssefian
Designer:
Aram Youssefian
Illustrator:
Aram Youssefian

Client:
Dr. Richard Belli
Nature of Business:
Podiatry
Design Firm:
McMillian Design
Art Director:
William McMillian
Designer:
William McMillian
Illustrator:
William McMillian

Client:
Bowes Leadership Group
Nature of Business:
Human resources consultancy
Design Firm:
Brown Communications Group
Art Director:
Dave Gowryluk
Designer:
Kathryn Balacko

Client:
Tarmac
Nature of Business:
Construction
Design Firm:
Enterprise IG
Art Director:
Stuart Redfern
Designers:
Simon Case, Nick Renn

Client:
Concept Interactive, Inc.
Nature of Business:
Custom Web applications,
document imaging and multimedia
Design Firm:
Kircher
Art Director:
Bruce E. Morgan
Designer:
Bruce E. Morgan

Client:
Le Petit Chef
Nature of Business:
Products for children
Design Firm:
Insight Design Communications
Art Directors:
Sherrie Holdeman,
Tracy Holdeman
Designers:
Sherrie Holdeman,
Tracy Holdeman
Illustrators:
Sherrie Holdeman,
Tracy Holdeman

Client:
Doublegreen Landscapes
Nature of Business:
Landscaping
Design Firm:
Evenson Design Group
Art Director:
Stan Evenson
Designer:
Judy K. Lee

Client:
DenRay Tire
Nature of Business:
Tire retailer
Design Firm:
Brown Communications Group
Designer:
Tim Kroeker

Client:
Eisenbergs Skatepark
Nature of Business:
Skating facility
Design Firm:
Eisenberg And Associates
Art Director:
Larry White
Designer:
Larry White

Client:
Bradbury Design Inc.
Nature of Business:
Graphic design
Design Firm:
Bradbury Design Inc.
Art Director:
Catharine Bradbury
Designer:
Bradbury Design Inc.

Client:
CS Creative/American Airlines
Nature of Business:
Flight attendant training
Design Firm:
John Evans Design
Art Directors:
John Evans, Lindy Slayton
Designer:
John Evans
Illustrator:
John Evans

Client:
Fire Networks/Squires & Co.
Nature of Business:
Computer security software
Design Firm:
John Evans Design
Art Directors:
John Evans, Paul Black
Designer:
John Evans
Illustrator:
John Evans

Client:
GS Design, Inc.
Nature of Business:
Communications and design
Design Firm:
GS Design, Inc.
Art Director:
Dave Kotlan
Designer:
Dave Kotlan

Client:
Gettuit.com
Nature of Business:
Provider of customized work
engine applications
Design Firm:
Hornall Anderson
Design Works, Inc.
Art Director:
Jack Anderson
Designers:
Kathy Saito, Gretchen Cook,
James Tee, Julie Lock, Henry Yiu,
Sonja Max

gettuit.com

Client:
Hyde Park Gym
Nature of Business:
Exercise facility
Design Firm:
Sibley/Peteet Design
Art Directors:
Matt Heck, Mark Brinkman
Designer:
Mark Brinkman
Illustrator:
Mark Brinkman

Client:
Hollin Frankfurt
Nature of Business:
Architecture
Design Firm:
Karl Design
Art Director:
Andreas Karl
Designer:
Andreas Karl
Illustrator:
Andreas Karl

INDIEVIDUAL

Client:
INDIEVIDUAL
Nature of Business:
Book publishing
Design Firm:
Other*
Designer:
Alex Fea
Creative Director:
Mike Reed

Client:
Design & Image Communications
Nature of Business:
Graphic design and marketing
Design Firm:
Design & Image
Art Director:
Tasso Stathopulos
Designer:
Tasso Stathopulos

Client:
THE Iam GROUP, INC.
Nature of Business:
Image and identity management
Design Firm:
THE Iam GROUP, INC.
Art Director:
Rachael Miller
Designer:
Rachael Miller
Illustrator:
Rachael Miller
Creative Director:
Lee Elliot

Client:
Kaepa
Nature of Business:
Shoe manufacture
Design Firm:
RBMM
Designer:
Horacio Cobos

Client:
Innovative Research
Nature of Business:
Print media research
Design Firm:
Peterson & Company
Art Director:
Bryan Peterson
Designer:
Bryan Peterson
Illustrator:
Bryan Peterson

Client:
IMC Financial
Nature of Business:
General financial institution
Design Firm:
Insight Design Communications
Art Directors:
Sherrie Holdeman,
Tracy Holdeman
Designers:
Sherrie Holdeman,
Tracy Holdeman
Illustrators:
Sherrie Holdeman,
Tracy Holdeman

Client:
BBK Studio
Nature of Business:
Graphic design services
and consultancy
Design Firm:
BBK Studio
Art Director:
Yang Kim
Designer:
Yang Kim

bbkstudio / 5242 Plainfield NE / Grand Rapids MI 49525-1047 /

bbkstudio / Kevin Budelmann /34 10/pub /

kevin@bbkstudio.com / tel 616-447-1460 /x 101/

fax 616-447-1481 / www.bbkstudio.com / 5242 Plainfield NE /

Grand Rapids MI 49525-1047/ BFA Carnegie Mellon /

Stule bar Gestaltung St. Gallen / dtl sor la 5pm bsp /

substance over style / style over banality / kona/

bbkstudio / tel 616-447-1460 / fax 616-447-1481 / www.bbkstudio.com / 5242 Plainfield NE / Grand Rapids MI 49525-1047 /

Client:
Coquico
Nature of Business:
Toy company
Design Firm:
Supon Design Group
Art Director:
Supon Phornirunlit
Designer:
Pum Mek-aroonreung

175 STRAFFORD AVENUE
SUITE ONE, PMB 310
WAYNE, PA 19087-3386

ROBERT J. WILSON
executive vice president

175 STRAFFORD AVENUE
SUITE ONE, PMB 310
WAYNE, PA 19087-3386
TELEPHONE 610 642 9382 EXT.2
FACSIMILE 610 642 8424
EMAIL bwilson@coquico.com

www.coquico.com

Client:
VMF Capital
Nature of Business:
Investment management
and consultancy
Design Firm:
BBK Studio
Art Directors:
Yang Kim, Kevin Budelmann
Designer:
Steven Joswick

Client:
MissionAir
Nature of Business:
Corporate air charter
Design Firm:
Brown Communications Group
Art Director:
Tim Kroeker
Designer:
Morris Antosh

Client:
Minelals Education Victoria
Nature of Business:
Government education
organization
Design Firm:
Marcus Lee Design
Art Director:
Marcus Lee
Designer:
Shane Hurt

Client:
Melbourne Town Centre/
Secker Brinker Design
Nature of Business:
Shopping mall
Design Firm:
John Evans Design
Art Directors:
John Evans, Beth Brink
Designer:
John Evans
Illustrator:
John Evans

Clients:
Robert Sharp, Tom Bourdeaux
Nature of Business:
Mixed use office space
Design Firm:
Walker Creative, Inc.
Art Director:
Tim Walker
Designer:
Daniel Bertalotto

Client:
Mavericks
Nature of Business:
Western style clothing
Design Firm:
RBMM
Designer:
Shazne Washburn

Client:
Media Temple
Nature of Business:
Website development
Design Firm:
Focus Design and
Marketing Solutions
Art Director:
Aram Youssefian
Designer:
Aram Youssefian
Illustrator:
Aram Youssefian

Client:
Network Technology Group
Nature of Business:
Network system design
and installation
Design Firm:
Peterson & Company
Art Director:
Nhan Pham
Designer:
Nhan Pham
Illustrator:
Nhan Pham

Client:
TeraStor
Nature of Business:
Electronic digital storage
Design Firm:
Mortensen Design
Art Director:
Gordon Mortensen
Designers:
Diana Kauzlarich, Wendy Chon

Client:
Clare Wade Communications
Nature of Business:
Public relations
Design Firm:
Square One Design
Art Director:
Lin Ver Meulen
Designer:
Martin Schoenborn
Illustrator:
Jon Post
Printer:
D&D Printing

735 Lockwood St NE
Grand Rapids MI 49503-3541
P 616.458.7421
F 616.458.7463
E clwadecom@aol.com

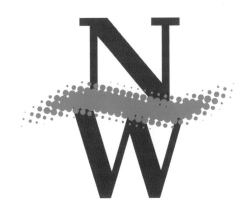

Client:
North Wind Yachts
Nature of Business:
Shipbuilding
Design Firm:
Sonsoles
Art Director:
Sonsoles Llorens
Designer:
Sonsoles Llorens
Illustrator:
Sonsoles Llorens

O's CAMPUS CAFE

Client:
O's Café
Nature of Business:
Fresh food café at
University of Texas
Design Firm:
Sibley/Peteet Design
Art Directors:
Rex Peteet, Matt Heck
Designer:
Rex Peteet
Illustrator:
Rex Peteet

O's CATERING

Client:
O's Café
Nature of Business:
Restaurant at University of Texas
Design Firm:
Sibley/Peteet Design
Art Directors:
Rex Peteet, Matt Heck
Designer:
Rex Peteet
Illustrator:
Rex Peteet

Client:
Java Post Production
Nature of Business:
Film and video production
Design Firm:
Brown (Regina)
Art Directors:
Michael Woroniak, Erik Norbraten
Designers:
Erik Norbraten, Michael Woroniak

Client:
The Pagnato Group
Nature of Business:
Stock brokerage
Design Firm:
Smarteam Communications
Art Director:
Gary Ridley
Designer:
Brent Almond

Client:
Parable Communications
Nature of Business:
Graphic design and
communications
Design Firm:
Parable Communications
Art Director:
David Craib
Designer:
Tania Senior

CASA
INTERIORS

CASA
INTERIORS philippa duffy

56 Maygrove Road, West Hampstead, London NW6 2ED
t/f 020 7328 7371 m 07702 807 493

56 Maygrove Road, West Hampstead, London NW6 2ED
t/f 020 7328 7371 m 07702 807 493

Client:
Public Executions
Nature of Business:
Film production
Design Firm:
RBMM
Designer:
Tom Nynas

Client:
Reliable Heating and Cooling
Nature of Business:
Residential and commercial
heating and cooling
Design Firm:
Brown (Regina)
Art Director:
Erik Norbraten
Designer:
Erik Norbraten

Client:
k/c/e Marketing Services
Nature of Business:
Castle, hotel and vinery
Design Firm:
Karl Design
Art Director:
Andreas Karl
Designer:
Andreas Karl
Illustrator:
Andreas Karl

DR.DANGSTORP
LAKESHORE DENTAL CLINIC
NORTHGATE DENTAL CLINIC

DR.DANGSTORP
LAKESHORE DENTAL CLINIC
NORTHGATE DENTAL CLINIC

DR.DANGSTORP
LAKESHORE DENTAL CLINIC
NORTHGATE DENTAL CLINIC

LAKESHORE DENTAL CLINIC
LAKESHORE MALL, 1380 23RD AVE.
REGINA, SK S4S 3S5

NORTHGATE DENTAL CLINIC
NORTHGATE MALL, 489 ALBERT ST. N.
REGINA, SK S4R 3C4

LAKESHORE DENTAL CLINIC, LAKESHORE MALL, 1380 23RD AVE., REGINA, SK S4S 3S5 Ph. (306) 757-6727
NORTHGATE DENTAL CLINIC, NORTHGATE MALL, 489 ALBERT ST. N., REGINA, SK S4R 3C4 Ph. (306) 775-2767
Fax (306) 791-0790 E-mail: drdaryl@aol.com

Client:
Dr. Dangstorp
Nature of Business:
Dentistry
Design Firm:
Bradbury Design Inc.
Art Director:
Catharine Bradbury
Designer:
Bradbury Design Inc.

Client:
Reynolds Custom Homes
Nature of Business:
Custom home construction
Design Firm:
Sibley/Peteet Design
Art Director:
Mark Brinkman
Designer:
Mark Brinkman

Client:
Reading Entertainment
Nature of Business:
Real estate/entertainment
Design Firm:
Evenson Design Group
Art Director:
Stan Evenson
Designers:
Karen Barranco, Mark Sojka,
Peggy Woo

Client:
Standard Printing
Nature of Business:
Printing
Design Firm:
Dotzero Design
Art Directors:
Jon Wippich, Karen Wippich

Client:
Buckin' Bass Brewing
Nature of Business:
Brewery
Design Firm:
Compass Design
Designers:
Mitchell Lindgren, Tom
Rich McGowen
Illustrator:
Tom Arthur

Client:
Story Garden Productions
Nature of Business:
Children's movie production
Design Firm:
Eisenberg And Associates
Art Director:
Dona Mitchum
Designer:
Dona Mitchum
Illustrator:
Dona Mitchum

Client:
Simulprobe Technologies
International Inc.
Nature of Business:
Environmental technology
Design Firm:
Frank D'Astolfo Design
Art Director:
Frank D'Astolfo
Designer:
Frank D'Astolfo

Client:
Space Needle
Nature of Business:
Seattle tourist attraction and icon
Design Firm:
Hornall Anderson
Design Works, Inc.
Art Director:
Jack Anderson
Designers:
Mary Hermes, Gretchen Cook,
Andrew Smith, Alan Florsheim,
Cliff Chung, Julie Lock,
Holly Craven, Belinda Bowling,
Elmer De LaCruz
Illustrators:
Andrew Smith, Gretchen Cook

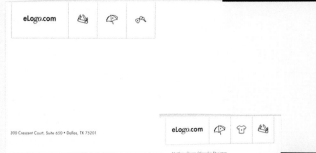

eLogo.com

300 Crescent Court, Suite 650 • Dallas, TX 75201

eLogo.com

Matthew Dixon / Graphic Designer

300 Crescent Court
Suite 650
Dallas, TX 75201
matthewd@elogo.com

214

756.6250 main
756.6230 fax
756.6376 direct

300 Crescent Court, Suite 650 • Dallas, TX 75201 • 214.756.6250 main • 214.756.6230 fax

Client:
eLogo.com
Nature of Business:
Online supplier of
promotional items
Design Firm:
Eisenberg And Assoc
Art Director:
Gwen Haberman
Designer:
Gwen Haberman

Client:
Epsilon Bar Café
Nature of Business:
Café
Design Firm:
Chimera Design
Art Director:
John Magart
Designer:
John Magart

epsilon

pt finders lane
& russel street
melbourne
9654 6699

Client:
Stillwater Mining Company
Nature of Business:
Platinum & palladium mining
Design Firm:
Design and Image
Art Director:
Tasso Stathopulos
Designer:
Cindy Gombert

Client:
TechCom Partners
Nature of Business:
High-tech public relations
Design Firm:
Eisenberg And Associates
Art Director:
Cesar Sanchez
Designer:
Cesar Sanchez

Client:
Utilities Protection Center
Nature of Business:
Protection for utilities
infrastructure
Design Firm:
Wages Design
Art Director:
Bob Wages
Designers:
Bob Wages, Matt Taylor

Client:
Underground Storage/Dunn-Allen
Design Agency
Nature of Business:
Underground record storage
Design Firm:
Dotzero Design
Art Directors:
Karen Wippich, Jon Wippich

Client:
Slovenska knjiga, Ljubljana
Nature of Business:
Publishing
Design Firm:
KROG
Art Director:
Edi Berk
Designer:
Edi Berk

Client:
Vitria
Nature of Business:
E-business platform provider
Design Firm:
Gee + Chung Design
Art Directors:
Earl Gee, Fani Chung
Designers:
Earl Gee, Fani Chung
Illustrators:
Earl Gee, Fani Chung

Client:
Arts Court
Nature of Business:
Arts center
Design Firm:
Parable Communications
Art Director:
David Craib
Designer:
Paul Cavanaugh
Photographer:
Jim Cochrane
Product Design:
The Design Workshop

Client:
Vector
Nature of Business:
Specialized financial services
Design Firm:
Signi Design
Art Director:
Daniel Castelao
Designer:
Daniel Castelao

Client:
Versaterm Inc.
Nature of Business:
Computer communications
systems
Design Firm:
Neville Smith Graphic Design
Art Director:
Neville Smith
Designer:
Neville Smith
Illustrator:
Neville Smith

Client:
Victory
Nature of Business:
Dallas arena district
Design Firm:
RBMM
Designer:
Tom Nynas

Client:
Focus Design & Marketing
Solutions
Nature of Business:
Graphic design
Design Firm:
Focus Design & Marketing
Solutions
Art Director:
Aram Youssefian
Designer:
Aram Youssefian

edia
f Business:
ng media strategy
Firm:
Communications
tor:
aib
r:
aib

Client:
Arthur Andersen
Nature of Business:
Business consultancy
Design Firm:
Enterprise IG
Art Directors:
David Freeman, Stuart Redfern
Designer:
Tammy Kustow
Photographer:
Magnum

Client:
Mad Cow Studio
Nature of Business:
Photography
Design Firm:
Brown (Regina)
Art Directors:
Michael Woroniak, Dan Carr
Designers:
Michael Woroniak, Dan Carr
Illustrator:
Dan Carr

Client:
Sundog Interactive
Nature of Business:
Interactive consultancy
Design Firm:
Planet Propaganda
Art Director:
Dana Lytle
Designer:
Jamie Karlin
Illustrator:
Lin Wilson

Client:
Excel
Nature of Business:
Meat processing
Design Firm:
Gardner Design
Art Director:
Chris Parks
Designers:
Chris Parks, Travis Brown

Client:
Design & Image Communications
Nature of Business:
Graphic design and marketing
Design Firm:
Design & Image
Art Director:
Tasso Stathopulos
Designer:
Tasso Stathopulos

Client:
Twelve Horses
Nature of Business:
Application service provider
Design Firm:
Hornall Anderson Design
Works, Inc.
Art Director:
Jack Anderson
Designers:
Jack Anderson, Lisa Cerveny,
Mary Chin Hutchison,
Holly Craven, Elmer De LaCruz

TWELVE HORSES

Client:
St. Louis Zoo
Nature of Business:
Zoo
Design Firm:
Kiku Obata & Company
Designer:
Rich Nelson
Illustrator:
Rich Nelson

CHILDREN'S
ZOO

Client:
CS Creative
Nature of Business:
Design and advertising
Design Firm:
John Evans Design
Art Directors:
John Evans, Cindy Slayton
Designer:
John Evans
Illustrator:
John Evans

Client:
Alphabet Soup
Nature of Business:
Children's toy store
Design Firm:
Sayles Graphic Design
Art Director:
John Sayles
Designer:
John Sayles
Illustrator:
John Sayles

Client:
The Jerde Partnership
Nature of Business:
Architecture
Design Firm:
Selbert Perkins Design
Art Director:
Robin Perkins
Designers:
John Lutz, Amy Lucas,
Doug Bunker

Client:
Portofino Bay Hotel
Nature of Business:
Hotel and resort
Design Firm:
David Carter Design Associates
Art Director:
Lori B. Wilson
Designer:
Tien Pham

Client:
University of Miami Rosenstiel
School of Marine and
Atmospheric Science
Nature of Business:
Sustaining ocean wildlife
Design Firm:
Barrett Laidlaw Gervais
Art Director:
David Laidlaw
Designer:
David Laidlaw
Illustrator:
David Laidlaw

Client:
Fed By Faith
Nature of Business:
Christian catering company
Design Firm:
Lambert Design Studio
Art Director:
Christie Lambert Rasmussen
Designer:
Amy Sharp
Illustrator:
Amy Sharp

Client:
St. James Bay
Nature of Business:
Golf resort and home
development
Design Firm:
Eisenberg and Associates
Art Director:
Dona Mitchum
Designer:
Dona Mitchum

Client:
Atlantis, Paradise Island
Nature of Business:
Hotel, resort and casino
Design Firm:
David Carter Design Associates
Art Director:
Lori B. Wilson
Designer:
Tien Pham

Client:
Methodologie, Inc.
Nature of Business:
Brand management,
identity development,
marketing communications
and interactive design
Design Firm:
Methodologie, Inc.
Art Directors:
Anne Trauer, Dale Hart
Designer:
Daniele Monti

Client:
Piranha
Nature of Business:
Metal fabrication
Design Firm:
Gardner Design
Art Director:
Bill Gardner
Designer:
Chris Parks

Client:
Jailbait
Nature of Business:
Web consultancy
Design Firm:
RBMM
Designer:
Tom Nynas

Client:
Saltgrass Steak House
Nature of Business:
Restaurant
Design Firm:
John Evans Design
Art Director:
John Evans
Designer:
John Evans
Illustrator:
John Evans

Client:
Hammerquist & Halverson
Nature of Business:
Advertising
Design Firm:
Hornall Anderson Design
Works, Inc.
Art Director:
Jack Anderson
Designer:
Mike Calkins
Illustrator:
Mike Calkins

Client:
Bow Wow Bean
Nature of Business:
Dog product boutique
Design Firm:
Brainforest, Inc.
Art Director:
Nils Bunde
Designer:
Melissa Gordon

Client:
Moon Doggie
Nature of Business:
Holding company
Design Firm:
Eisenberg & Associates
Art Director:
Marcus Dickerson
Designer:
Marcus Dickerson
Illustrator:
Marcus Dickerson

Client:
Center For Children
Nature of Business:
Education of challenged children
Design Firm:
Morris Creative
Art Director:
Steven Morris
Designers:
Steven Morris, Shelly Hays
Illustrator:
Steven Morris
Copywriter:
Monica Armstrong

Client:
Axis Personal Trainers & Spa
Nature of Business:
Fitness facility
Design Firm:
Arias Associates
Art Director:
Mauricio Arias
Designer:
Maral Sarkis
Photographer:
John Mickelson,
Paul Fairchild Photography
Copywriter:
Dawn Mortensen

A X I S

PERSONAL TRAINERS AND SPA

Client:
Tallgrass Beef
Nature of Business:
Beef production
Design Firm:
Gardner Design
Art Directors:
Bill Gardner, Brian Miller
Designer:
Bill Gardner
Illustrator:
Bill Gardner

Client:
Solutia
Nature of Business:
Chemical products and services
Design Firm:
Stan Gellman Graphic Design
Art Director:
Barry Tilson
Designer:
Barry Tilson

Client:
Megafab
Nature of Business:
Metal fabrication
Design Firm:
Gardner Design
Art Director:
Bill Gardner
Designer:
Bill Gardner
Illustrator:
Bill Gardner

Client:
Java Post Production
Nature of Business:
Film and video production
Design Firm:
Brown (Regina)
Art Directors:
Michael Woroniak, Erik Norbraten
Designers:
Erik Norbraten, Michael Woroniak

JAVA POST

P R O D U C T I O N

JAVA POST

P R O D U C T I O N

JACK TUNNICLIFFE

2345 Smith Street
Regina, Saskatchewan, Canada
S4P 2P7
P 306.777.0150 F 306.352.8558
E-MAIL javapost@sk.sympatico.ca

2345 Smith Street Regina, Saskatchewan, Canada S4P 2P7
P 306.777.0150 F 306.352.8558 E-MAIL javapost@sk.sympatico.ca

JOHN (CROWE)

Client:
John Crowe Photography
Nature of Business:
Photography
Design Firm:
Gardner Design
Art Director:
Brian Miller
Designer:
Brian Miller

SecuraSpeed

Client:
Australian Paper
Nature of Business:
Paper manufacture
Design Firm:
Marcus Lee Design
Art Director:
Marcus Lee
Designer:
George Margaritis

Client:
American Cancer Society
Nature of Business:
Non-profit health organization
dedicated to eliminating cancer
Design Firm:
Sayles Graphic Design
Art Director:
John Sayles
Designer:
John Sayles
Illustrator:
John Sayles

Client:
Alphabet Soup
Nature of Business:
Children's toy store
Design Firm:
Sayles Graphic Design
Art Director:
John Sayles
Designer:
John Sayles
Illustrator:
John Sayles

Client:
Sova
Nature of Business:
Language consultancy
Design Firm:
Igor Masnjak Design
Art Director:
Igor Masnjak
Designer:
Igor Masnjak

Client:
Evangelical Lutheran Church
Nature of Business:
Christian outreach for
lay ministers
Design Firm:
Brown (Regina)
Art Director:
Erik Norbraten
Designer:
Erik Norbraten

Client:
The Hayes Co.
Nature of Business:
Healthy bird feeders and houses
Design Firm:
Insight Design Communications
Art Directors:
Sherrie Holdeman,
Tracy Holdeman
Designer:
Chris Parks
Illustrator:
Chris Parks

Client:
Blue Rhino
Nature of Business:
Retail sculpture
Design Firm:
RBMM
Designer:
Tom Nynas

Client:
Spitzner Arzneimittel
Nature of Business:
Medicine and pharmaceutics
Design Firm:
FCB Design
Art Director:
Andreas Karl
Designer:
Andreas Karl
Illustrator:
Andreas Karl

Client:
Cruise West
Nature of Business:
Travel
Design Firm:
Belyea
Art Director:
Patricia Belyea
Designer:
Ron Lars Hansen

Client:
Sergeant's
Nature of Business:
Military cafeteria
Design Firm:
Gardner Design
Art Director:
Chris Parks
Designer:
Chris Parks

Client:
The Phenix Optical Co. Ltd.
Nature of Business:
Camera manufacture
Design Firm:
Kan & Lau Design Consultants
Art Directors:
Kan Tai-Keung, Chau So Hing
Designers:
Wang Yu-Long, Chau So Hing

Client:
Propper American
Nature of Business:
Retail apparel manufacture
(military style clothing)
Design Firm:
Stan Gellman Graphic Design
Art Director:
Barry Tilson
Designer:
Barry Tilson

Client:
La Luna Oil Company
Nature of Business:
Oil exploration
Design Firm:
Arias Associates
Art Director:
Mauricio Arias
Designers:
Mauricio Arias, Marites Algones
Illustrator:
Mauricio Arias

Client:
Cowtown Catering
Nature of Business:
Outdoor barbecues
Design Firm:
Design & Image
Art Director:
Tasso Stathopulos
Designer:
Michelle Lee
Illustrator:
Tasso Stathopulos

Client:
Food Fight
Nature of Business:
Restaurant
Design Firm:
Planet Propaganda
Art Director:
Dana Lytle
Designer:
Jamie Karlin

Client:
Bistecca
Nature of Business:
Restaurant
Design Firm:
Wang/Hutner Design
Art Directors:
Maria Wang-Horn, Sue Hutner
Designer:
Nita Ybarra

Client:
Polk County, Iowa
Nature of Business:
County administration
Design Firm:
Sayles Graphic Design
Art Director:
John Sayles
Designer:
John Sayles
Illustrator:
John Sayles

Client:
Bearcat Scanners/Coffee Black
Advertising
Nature of Business:
Scanners
Design Firm:
John Evans Design
Art Director:
John Evans
Designer:
John Evans
Illustrator:
John Evans

Client:
Australian Brewing Corporation
Nature of Business:
Brewery
Design Firm:
Marcus Lee Design
Art Director:
Marcus Lee
Designer:
George Margaritis

Client:
Ocean Fox Dive Shop
Nature of Business:
Charter dive shop
Design Firm:
Tom Fowler, Inc.
Art Director:
Thomas G. Fowler
Designer:
Thomas G. Fowler
Illustrator:
Thomas G. Fowler

Client:
Arias Associates
Nature of Business:
Design consultancy
Design Firm:
Arias Associates
Art Director:
Mauricio Arias
Designers:
Maral Sarkis, Melissa Kopecky
Printer:
Anderson Lithograph,
San Francisco

ONRADIO.COM serves online radio sites and other popular Internet desti-
nations with syndicated music and music-related content.

onradio.com

Client:
International Arts Movement
Nature of Business:
Artists' organization
Design Firm:
Frank D'Astolfo Design
Art Director:
Frank D'Astolfo
Designer:
Frank D'Astolfo

Client:
Persona Principle
Nature of Business:
Image marketing
Design Firm:
Two Dimensions Inc.
Art Director:
Kam Wai Yu
Designer:
Kam Wai Yu

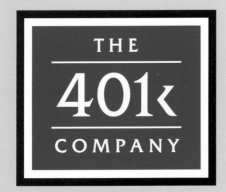

Client:
The 401(k) Company
Nature of Business:
401(k) retirement planning
Design Firm:
Sibley/Peteet Design
Art Director:
Rex Peteet
Designer:
Rex Peteet
Illustrator:
Rex Peteet

Client:
The Ultimate Kitchen
Nature of Business:
Custom kitchen design
Design Firm:
Evolution Studio
Art Director:
Marcus Braun
Designer:
Marcus Braun

[THE ULTIMATE KITCHEN]

Suite 101-1500
West Georgia Street
Vancouver, BC V6G 2Z6

Suite 101-1500 West Georgia Street Vancouver, BC V6G 2Z6
Telephone 604.688.2020 Facsimile 604.688.6033

[THE ULTIMATE KITCHEN]

Jutaek Kim

email: contact@theultimatekitchen.com website: www.theultimatekitchen.com

Client:
@Georgia
Nature of Business:
Real estate
Design Firm:
Energy Energy Design
Art Director:
Leslie Guidice
Designers:
Stacy Guidice,
Jeanette Aramburu
Illustrator:
Jeanette Aramburu

Client:
Paris Casino Resort
Nature of Business:
Hotel, resort and casino
Design Firm:
David Carter Design Associates
Art Director:
Ashley Barron
Designer:
Tabitha Bogard

Client:
Voltaire
Nature of Business:
Restaurant and bar
Design Firm:
Eisenberg & Associates
Art Director:
Marcus Dickerson
Designer:
Marcus Dickerson
Illustrator:
Marcus Dickerson

Client:
Magnet Studios
Nature of Business:
Media agency for human resource
recruitment
Design Firm:
Parable Communications
Art Directors:
David Craib, Mark Ury
Designer:
David Craib

Client:
CraftArt.com
Nature of Business:
Online gallery of fine art
and crafts
Design Firm:
Activenation
Art Director:
Ayoub Ahielmona
Designer:
Jason Lamb

StaffBridge

Client:
StaffBridge
Nature of Business:
Staffing
Design Firm:
Energy Energy Design
Art Director:
Leslie Guidice
Designers:
Stacy Guidice, Jeanette Aramburu

ifilm.com

Client:
ifilm
Nature of Business:
Internet film production
Design Firm:
BIRD Design
Designer:
Peter King Robbins

Client:
La Luna Oil Company
Nature of Business:
Oil exploration
Design Firm:
Arias Associates
Art Director:
Mauricio Arias
Designer:
Mauricio Arias
Illustrator:
Mauricio Arias

Client:
Katherine Watson
Nature of Business:
Event planning
Design Firm:
Parable Communications
Art Director:
David Craib
Designer:
Peter Watts
Photographer:
Eadwearu Muybridge

Client:
Information Technology Ventures
Nature of Business:
Information technology
investment
Design Firm:
Energy Energy Design
Art Director:
Leslie Guidice
Designers:
Stacy Guidice, Leslie Guidice
Illustrator:
Leslie Guidice

Client:
Essential Spirits
Nature of Business:
Distillery
Design Firm:
Arias Associates
Art Director:
Mauricio Arias
Designers:
Stephanie Yee, Steve Mortensen
Illustrator:
Harry Bates

Client:
Group Harmony
Nature of Business:
Organizational development and
human resources
Design Firm:
Brainforest, Inc.
Art Director:
Nils Bunde
Designer:
Melissa Gordon

Client:
Peters
Nature of Business:
Restaurant
Design Firm:
Neville Smith Graphic Design
Art Director:
Neville Smith
Designer:
Neville Smith
Illustrator:
Neville Smith

Client:
MPFree/MC
Nature of Business:
Online entertainment
Design Firm:
Morris Creative
Art Director:
Steven Morris
Designer:
Steven Morris
Illustrator:
Steven Morris

Client:
Mens
Nature of Business:
Communications and design
Design Firm:
Mens
Art Director:
Suncana Matijasevic
Designer:
Suncana Matijasevic
Illustrator:
Suncana Matijasevic
Copywriter:
Suncana Matijasevic

Client:
Frostad Ateiler
Nature of Business:
Bronze casting
Design Firm:
Energy Energy Design
Art Director:
Leslie Guidice
Designers:
Stacey Guidice, Robin Garner

Client:
Braincramps
Nature of Business:
Computer consulting and resale
Design Firm:
Gardner Design
Art Director:
Brian Miller
Designer:
Brian Miller

Client:
Frenchbread Productions
Nature of Business:
Music production
Design Firm:
Dotzero Design
Art Directors:
Jon Wippich, Karen Wippich

Client:
Harrison Smith
Nature of Business:
Online hair styling
Design Firm:
Brent Almond
Designer:
Brent Almond

Client:
YMCA
Nature of Business:
Youth organization
Design Firm:
Peterson & Company
Art Director:
Scott Ray
Designer:
Scott Ray
Illustrator:
Nhan Pham

Client:
Dammit
Nature of Business:
Promotional logo
Design Firm:
RBMM
Designer:
Tom Nynas

Client:
Reading Glasses To Go
Nature of Business:
Eyeglass store
Design Firm:
John Evans Design
Art Director:
John Evans
Designer:
John Evans
Illustrator:
John Evans

Client:
TrueVision Laser Center
Nature of Business:
Corporate foundation for
laser eye surgery
Design Firm:
Studio Hill Design Ltd.
Art Director:
Sandy Hill
Designer:
Mary Lambert

Client:
Studio International
Nature of Business:
Design and advertising
Design Firm:
Studio International
Art Director:
Boris Yubicio
Designer:
Boris Yubicio
Illustrator:
Igor Yubicio
Photographer:
Boris Yubicio

Client:
Sayles Graphic Design
Nature of Business:
Graphic design
Design Firm:
Sayles Graphic Design
Art Director:
John Sayles
Designer:
John Sayles
Illustrator:
John Sayles

Client:
Mike Stanley Freelance Video
Nature of Business:
Video production
Design Firm:
John Evans Design
Art Director:
John Evans
Designer:
John Evans
Illustrator:
John Evans

Client:
Regina Public Library Film Theatre
Nature of Business:
Repertory film theatre specializing
in world cinema screenings
Design Firm:
Brown (Regina)
Art Director:
Michael Woroniak
Designer:
Michael Woroniak

Client:
AIGA
Nature of Business:
Graphic design organization
Design Firm:
Gardner Design
Art Director:
Travis Brown
Designer:
Travis Brown

Client:
Red Letter Consulting
Nature of Business:
Marketing consultancy
Design Firm:
Spatchurst
Art Director:
Steven Joseph
Designer:
Nicky Hardcastle

Client:
4 Points Travel
Nature of Business:
Online travel agency
and guide
Design Firm:
Insight Design
Communications
Art Directors:
Sherrie Holdeman,
Tracy Holdeman
Designers:
Sherrie Holdeman,
Tracy Holdeman
Illustrators:
Sherrie Holdeman,
Tracy Holdeman

Client:
Touch Victoria
Nature of Business:
Touch football institute
Design Firm:
Chimera Design
Art Director:
John Magart
Designer:
Naomi Mace

Client:
Scienceworks Museum
Nature of Business:
Museum
Design Firm:
Marcus Lee Design
Art Director:
Marcus Lee
Designer:
George Margaritis

Client:
Tips Iron & Steel
Nature of Business:
Iron and steel fabrication
Design Firm:
Sibley/Peteet Design
Art Director:
Mark Brinkman
Designer:
Mark Brinkman

Client:
Gardner Design
Nature of Business:
Halloween cookout
Design Firm:
Gardner Design
Art Director:
Bill Gardner
Designer:
Bill Gardner

Client:
Artistree at the Forum
Nature of Business:
Community arts center
Design Firm:
Gardner Design
Art Director:
Brian Miller
Designer:
Brian Miller

Client:
Physique Enhancement
Nature of Business:
Body sculpture and
hair removal
Design Firm:
Insight Design
Communications
Art Directors:
Sherrie Holdeman,
Tracy Holdeman
Designers:
Sherrie Holdeman,
Tracy Holdeman
Illustrators:
Sherrie Holdeman,
Tracy Holdeman

서울정

SEOUL RESTAURANT COREA

Client:
Bae Suk Tae
Nature of Business:
Asian restaurant
Design Firm:
Sonsoles
Art Director:
Sonsoles Llorens
Designer:
Sonsoles Llorens
Illustrator:
Sonsoles Llorens
Photographer:
Rafael Vargas

Client:
Child Guidance Clinic
Nature of Business:
Child guidance
Design Firm:
Peterson & Company
Art Director:
Nhan Pham
Designer:
Nhan Pham
Illustrator:
Nhan Pham

Client:
Victorian Institute of Sport
Nature of Business:
Sports institute
Design Firm:
Chimera Design
Art Director:
John Magart
Designers:
John Magart,
Eric Orfanos
Illustrator:
Eric Orfanos

Client:
Tech-Point
Nature of Business:
Computer consultancy
Design Firm:
Gardner Design
Art Director:
Brian Miller
Designer:
Brian Miller

Client:
Martha McMillian
Nature of Business:
Art instruction
Design Firm:
McMillian Design
Art Director:
William McMillian
Designer:
William McMillian
Illustrator:
William McMillian

Client:
Corporate Innovations
Nature of Business:
Corporate clothing manufacture
Design Firm:
Marcus Lee Design
Art Director:
Marcus Lee
Designer:
Linda Ho

Client:
Milwaukee Racqueteers
Nature of Business:
Professional indoor
tennis team
Design Firm:
GS Design, Inc.
Art Director:
Mike Magestro
Designer:
Mike Magestro

Client:
3 Day Big & Tall
Nature of Business:
Music
Design Firm:
Duncan/Channon
Art Director:
Jacquie VanKeuren
Illustrator:
Jacquie VanKeuren
Photographer:
Will Yarbrough

Client:
CD Force
Nature of Business:
Compact disc distribution
Design Firm:
Insight Design
Communications
Art Directors:
Sherrie Holdeman,
Tracy Holdeman
Designers:
Sherrie Holdeman,
Tracy Holdeman
Illustrators:
Sherrie Holdeman,
Tracy Holdeman

Client:
Chuck's Newstand
Nature of Business:
Newspaper and
magazine stand
Design Firm:
Gardner Design
Art Director:
Brian Miller
Designer:
Brian Miller

Client:
Printing House Craftsman
Nature of Business:
Printing competition
Design Firm:
Gardner Design
Art Director:
Brian Miller
Designer:
Brian Miller

Client:
Zilliant
Nature of Business:
Computer software solutions
Design Firm:
Sibley/Peteet Design
Art Directors:
Matt Heck, Rex Peteet,
Mark Brinkman
Designers:
Rex Peteet, Matt Heck
Illustrator:
Rex Peteet

Client:
Winnserv
Nature of Business:
Housing placement for
adults with special needs
Design Firm:
Brown Communications Group
Art Director:
Dave Gowryluk
Designer:
Morris Antosh

Client:
Cycle Hedz
Nature of Business:
Biking club
Design Firm:
RBMM
Designer:
Tom Nynas

abcdefghijklmnopqrstuv

Stuart Heath
Copywriter

3 Paradise Row
London E2 9LE

T/F 020 7729 7854
M 07961 100035
E sj.heath@virgin.net

Client:
Stuart Heath
Nature of Business:
Copywriting
Design Firm:
Other*
Art Director:
Stuart Heath
Designer:
Alex Fea
Creative Director:
Mike Reed

Client:
Mariko Arts
Nature of Business:
Art gallery
Design Firm:
Design & Image
Art Director:
Tasso Stathopulos
Designer:
Tasso Stathopulos

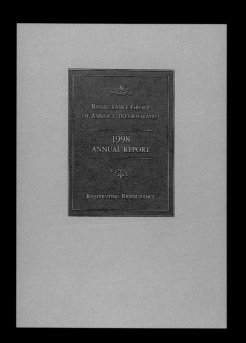

Client:
RGA
Nature of Business:
Reinsurance
Design Firm:
Group C Design
Art Director:
Tom Croghan
Designer:
Ria Sharon

Client:
Cibola
Nature of Business:
Fine cuisine restaurant based on
the seven lost cities of Cibola
Design Firm:
Gardner Design
Art Director:
Bill Gardner
Designer:
Chris Parks

Client:
MovieVille Video Corporation
Nature of Business:
Video retailer
Design Firm:
George Peters Design &
Illustration, Minneapolis
Art Director:
George Peters
Designer:
George Peters
Illustrator:
George Peters

Client:
Cypress Outdoor Clothing
Nature of Business:
Rugged outdoor clothing for men
Design Firm:
George Peters Design &
Illustration, Minneapolis
Art Director:
George Peters
Designer:
George Peters
Illustrator:
George Peters

Client:
Zilliant
Nature of Business:
Computer software solutions
Design Firm:
Sibley/Peteet Design
Art Director:
Matt Heck
Designers:
Matt Heck, David Guillory
Illustrators:
Rex Peteet, David Guillory

Client:
Bredar Waggoner Architecture
Nature of Business:
Architecture for sporting venues
Design Firm:
Gardner Design
Art Directors:
Bill Gardner, Travis Brown
Designer:
Travis Brown

Client:
Homestore.com
Nature of Business:
Online home resource
Design Firm:
Louey/Rubino Design Group
Art Director:
Robert Louey
Designer:
Alex Chao
Illustrator:
Alex Chao

Client:
Hydra Café
Nature of Business:
Café
Design Firm:
Chimera Design
Art Director:
John Magart
Designer:
John Magart

Client:
Red Devils
Nature of Business:
Girls' softball team
Design Firm:
Gardner Design
Art Director:
Chris Parks
Designer:
Chris Parks

Client:
Key City Transport Inc.
Nature of Business:
Furniture transport from
manufacturers to retail stores
Design Firm:
McCullough Creative Group
Art Director:
Jack McCullough
Designer:
Mark Jackson
Illustrator:
Mark Jackson

Client:
Purgatone Records
Nature of Business:
Record label
Design Firm:
Planet Propaganda
Art Director:
Kevin Wade
Designers:
Dan Ibarra, Kevin Wade,
Lin Wilson
Illustrator:
Lin Wilson

Client:
Winnipeg International
Children's Festival
Nature of Business:
Children's festival
Design Firm:
Brown Communications Group
Art Director:
Tim Kroeker
Designer:
Morris Antosh

Client:
Big Green Plants/Lee Casey
Nature of Business:
Online nursery and
landscape design
Design Firm:
John Evans Design
Art Directors:
John Evans, Lee Casey
Designer:
John Evans
Illustrator:
John Evans

Client:
EMI plc
Nature of Business:
Music
Design Firm:
Tor Pettersen & Partners
Art Director:
Tor Pettersen
Designer:
Scott Rosier

MAGNET STUDIOS

Client:
Magnet Studios
Nature of Business:
Media agency for human resource
recruitment
Design Firm:
Parable Communications
Art Director:
David Craib
Designer:
Peter Watts

You are a talent company. Start acting like one.

Client:
MOCAonline.com
Nature of Business:
Online museum
Design Firm:
Supon Design Group
Art Director:
Supon Phornirunlit
Designer:
Lillie Fujinaga

M O
C A
ONLINE.COM

MUSEUM OF COLLECTIBLE ARTS ONLINE
1523 F ST. NW, WASHINGTON, DC 20005
TEL 202 661 1762 FAX 202 234 1864
E-MAIL MOCA@MOCA.COM
WWW.MOCAONLINE.COM

M O
C A
ONLINE.COM

MUSEUM OF COLLECTIBLE ARTS ONLINE
1523 F ST. NW, WASHINGTON, DC 20005

Client:
Paul Chauncey Photography
Nature of Business:
Photography
Design Firm:
Gardner Design
Art Director:
Bill Gardner
Designers:
Bill Gardner, Brian Miller

Client:
Austin Film Festival
Nature of Business:
Film festival and screenwriters
conference
Design Firm:
Sibley/Peteet Design
Art Directors:
Carrie Eko, Mark Brinkman,
Marc Stephens
Designer:
Carrie Eko
Illustrator:
Carrie Eko

Client:
Greater Dallas Children's Chorus
Nature of Business:
Chorus
Design Firm:
RBMM
Designer:
Horacio Cobos

Client:
Mucho.com
Nature of Business:
Online resource for businesses
Design Firm:
Energy Energy Design
Art Director:
Leslie Guidice
Designers:
Leslie Guidice, Jeanette Aramburu
Illustrator:
Leslie Guidice

Client:
Cole Myer Direct
Nature of Business:
Mail order gifts
Design Firm:
Marcus Lee Design
Art Director:
Marcus Lee
Designer:
George Margaritis

Client:
IBOC, Inc.
Nature of Business:
National restaurant franchise
Design Firm:
GS Design, Inc.
Art Director:
Mike Magestro
Designer:
Mike Magestro
Illustrator:
Mike Magestro

FOUR NORTH MICHIGAN AVENUE CHICAGO, ILLINOIS 60611 312 239 4030 T 312 239 4000 F

Client:
Park Hyatt Hotel Chicago
Nature of Business:
Restaurant
Design Firm:
Louey/Rubino Design Group
Art Director:
Robert Louey
Designer:
Alex Chao

Client:
Wardrobe
Nature of Business:
Clothing boutique
Design Firm:
Sibley/Peteet Design
Art Directors:
Marc Stephens, Mark Brinkman
Designer:
Marc Stephens

Client:
The Fitness Choice
Nature of Business:
Personal training
Design Firm:
IE Design
Art Director:
Marcie Carson
Designer:
Marcie Carson

Client:
Red Ella
Nature of Business:
Clothing boutique
Design Firm:
Born to Design
for Bonneau Production Services
Art Director:
Todd Adkins
Designer:
Todd Adkins
Illustrator:
Todd Adkins

Client:
T-26
Nature of Business:
Type foundry
Design Firm:
Morris Creative
Art Director:
Steven Morris
Designer:
Steven Morris
Illustrator:
Steven Morris

Client:
Planet Salon
Nature of Business:
Hair salon
Design Firm:
Dotzero Design
Art Directors:
Karen Wippich, Jon Wippich

Client:
Andrew Tamerius Photography
Nature of Business:
Photography
Design Firm:
Dotzero Design
Art Directors:
Karen Wippich, Jon Wippich

Client:
Iron Easel
Nature of Business:
Wrought iron yard art sculptures
Design Firm:
Gardner Design
Art Directors:
Bill Gardner, Travis Brown
Designer:
Travis Brown

QIC

Enterprise IG

Client:
Enterprise IG
Nature of Business:
Internal review of company work
Design Firm:
Enterprise IG
Art Directors:
David Freeman, Jonny Lang
Designer:
James Sandersen
Photographer:
Jonathon Knowles

To complement the interior environment, Enterprise IG's designers worked on external elements such as pylons and signage, for the former doing extensive research not only to arrive at an original shape but also one that could be manufactured and maintained simply and at a reasonable cost. These new systems are now being rolled out across all

of different products was involved alongside the two main ones, such as accessories and the motorsport programme. QIC was also valuable, both Ryan and Sour agree. Firstly, it provided a focus for comment, encouragement and feedback, at regular intervals; "there's a risk of losing focus on a long-term project," according to Leslie Ryan.

Client:
Museum of Cakes
Nature of Business:
Pastry company
Design Firm:
Supon Design Group
Art Director:
Supon Phornirunlit
Designer:
Michele Howley
Illustrator:
Michele Howley

Delicious Works of Art

Delicious Works of Art

Scott Snelgrove
1331 10th Street, NW • Washington, DC • 20001
P 202.903.8883 • F 202.518.9758
scott@museumofcakes.com
www.museumofcakes.com

Delicious Works of Art

Scott Snelgrove • 1331 10th Street, NW • Washington, DC • 20001

1331 10th Street, NW • Washington, DC • 20001 • F 202.903.8883 • F 202.518.9758 • www.museumofcakes.com

Client:
Domaine Haleaux
Nature of Business:
Winery
Design Firm:
RBMM
Designer:
Tom Nynas

Client:
Wildflower Bread Company
Nature of Business:
Bakery specializing in Euro-artisan breads
Design Firm:
Estudio Ray
Art Directors:
Joe Ray, Chris Ray
Designer:
Leslie Link
Illustrator:
Joe Ray

Client:
Native Planet
Nature of Business:
Parent company for a line of fruit juices, frozen drinks and supplements
Design Firm:
Estudio Ray
Art Directors:
Joe Ray, Chris Ray
Designer:
Leslie Link

Client:
Buckin' Bass Brewing Co.
Nature of Business:
Brewery
Design Firm:
Compass Design
Designers:
Mitchell Lindgren, Tom Arthur,
Rich McGowen
Illustrator:
Tom Arthur

Client:
Wichita Blues Society
Nature of Business:
Promotion of blues music
performances
Design Firm:
Dotzero Design
Art Directors:
Karen Wippich, Jon Wippich

Client:
City of St. Charles, Missouri
Nature of Business:
Beautification commission
Design Firm:
Stan Gellman Graphic Design
Art Director:
Mike Donovan
Designer:
Mike Donovan

Client:
World Wide Sports
Nature of Business:
Women's' professional football
team
Design Firm:
Compass Design
Designers:
Mitchell Lindgren, Tom Arthur,
Rich McGowen
Illustrator:
Tom Arthur

Client:
Engfer Pizza Works
Nature of Business:
Restaurant
Design Firm:
Energy Energy Design
Art Director:
Leslie Guidice
Designer:
Stacy Guidice
Illustrator:
Tim Harris

Client:
Les Piafs
Nature of Business:
Sale of vintage goods
Design Firm:
Belyea
Art Director:
Patricia Belyea
Designer:
Christian Salas

Client:
Paris Casino Resort
Nature of Business:
Hotel, resort and casino
Design Firm:
David Carter Design Associates
Art Director:
Ashley Barron
Designer:
Ashley Barron
Illustrator:
Dan Piraro

le café

île st. louis

Client:
Ajuntament de Barcelona.
Medi Ambient
Nature of Business:
Ecology forum
Design Firm:
Sonsoles
Art Director:
Sonsoles Llorens
Designer:
Sonsoles Llorens
Illustrator:
Sonsoles Llorens

Client:
O'Brien Pharmacy
Nature of Business:
Holistic compounding pharmacy
Design Firm:
Willoughby Design Group
Art Director:
Nicole Satterwhite
Designer:
Nicole Satterwhite

4321 Washington, Suite 2020, Kansas City, Missouri 64111
[816] 531 6765 [800] 627 4360 [816] 531 4933 fax

Lisa Everett
Pharmacist, FACA
Certified Clinical Nutritionist

4321 Washington, Suite 2020
Kansas City, Missouri 64111

[816] 531 6765 [800] 627 4360
[816] 531 4933 fax

4321 Washington, Suite 2020
Kansas City, Missouri 64111

H. M. Everett *Pharmacist Emeritus* Lisa Everett *Pharmacist, CCN, FACA*
Eric Everett *Pharmacist, CCN, FSACP* Kristy Timmons *Pharmacist*

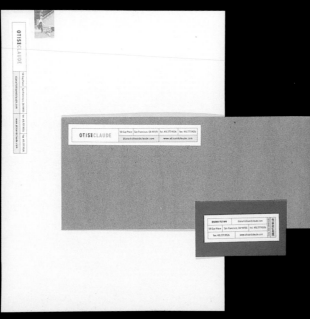

Client:
Otis and Claude
Nature of Business:
Dog toy design and manufacture
Design Firm:
Duncan/Channon
Art Director:
Jacquie VanKeuren

Client:
New World China
Nature of Business:
China project: investment,
development and management
Design Firm:
Kan & Lau Design Consultants
Art Director:
Kan Tai-Keung
Designers:
Lam Wai Hung, Pazu Lau

Client:
Profit Master Canada
Nature of Business:
Software development
Design Firm:
Brown Communications Group
Art Director:
Tim Kroeker
Designer:
Leighton Wiebe

Client:
On Wo Tong
Nature of Business:
Modern Chinese herbal clinic
Design Firm:
Kan & Lau Design Consultants
Art Directors:
Freeman Lau Siu Hong,
Veronica Cheung
Designers:
Veronica Cheung, Lam Wai Hung

PREVAIL

PREVAIL

P. O. Box 100 Marietta, GA 30061-0100

THINKING SKILLS THAT FACILITATE INNOVATION.

GRANT E. TODD president

PREVAIL

P. O. Box 100 Marietta, GA 30061-0100

T] 770 426 1008 F] 770 420 8001 www.prevail.org

THINKING SKILLS THAT FACILITATE INNOVATION. P. O. Box 100 Marietta, GA 30061-0100

T] 770 426 1008 F] 770 420 8001 www.prevail.org

Client:
Buckin' Bass Brewing Co.
Nature of Business:
Brewery
Design Firm:
Compass Design
Designers:
Mitchell Lindgren, Tom Arthur,
Rich McGowen
Illustrator:
Tom Arthur

Client:
Buckin' Bass Brewing Co.
Nature of Business:
Brewery
Design Firm:
Compass Design
Designers:
Mitchell Lindgren, Tom Arthur,
Rich McGowen
Illustrator:
Tom Arthur

Client:
Portofino Bay Hotel
Nature of Business:
Hotel and resort
Design Firm:
David Carter Design Associates
Art Director:
Lori B. Wilson
Designer:
Emily Cain
Illustrator:
Dan Piraro

Client:
Red Wing Foods
Nature of Business:
Specialty food distribution
Design Firm:
Compass Design
Designers:
Mitchell Lindgren, Tom Arthur,
Rich McGowen

Client:
David Software
Nature of Business:
Software
Design Firm:
George Peters Design &
Illustration, Minneapolis
Art Director:
George Peters
Designer:
George Peters
Illustrator:
George Peters

Client:
Stage Inc.
Nature of Business:
Performing arts center
Design Firm:
Paz Design Group
Art Director:
Von Glitschka
Designer:
Von Glitschka
Photographer:
Von Glitschka

Client:
Red Devils
Nature of Business:
Girls' softball team
Design Firm:
Gardner Design
Art Director:
Chris Parks
Designer:
Chris Parks

133

Client:
TruckSource Management Inc.
Nature of Business:
Management tools for trucking
Design Firm:
Bradbury Design Inc.
Art Director:
Catharine Bradbury
Designer:
Bradbury Design Inc.

Client:
Carlos O'Kelly's
Nature of Business:
Restaurant
Design Firm:
Gardner Design
Art Director:
Chris Parks
Designer:
Chris Parks
Illustrator:
Chris Parks

Client:
Excel
Nature of Business:
Meat processing
Design Firm:
Gardner Design
Art Director:
Brian Miller
Designer:
Brian Miller

Client:
T. B. Guide Company
Nature of Business:
Hunting and fishing guide service
Design Firm:
Gardner Design
Art Director:
Travis Brown
Designer:
Travis Brown
Illustrator:
Travis Brown

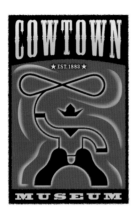

Client:
Cowtown Museum
Nature of Business:
Western historical society
Design Firm:
Gardner Design
Art Director:
Travis Brown
Designer:
Travis Brown

Client:
El Paso Chile Company
Nature of Business:
"South of the Border" food sales
Design Firm:
RBMM
Designer:
Tom Nynas

Client:
Tropical Sportswear International
Nature of Business:
Men's and women's
fashion apparel
Design Firm:
Sibley/Peteet Design
Art Director:
Rex Peteet
Designers:
Rex Peteet, Carrie Eko
Illustrator:
Peter Kramer
Ad Agency:
Sicola Martin

Client:
Maximum Lawncare
Nature of Business:
Lawn care
Design Firm:
Gardner Design
Art Director:
Bill Gardner
Designer:
Bill Gardner
Illustrator:
Bill Gardner

Client:
Errand Bees
Nature of Business:
Executive errand services
Design Firm:
Focus Design and Marketing
Solutions
Art Director:
Aram Youssefian
Designer:
Aram Youssefian
Illustrator:
Aram Youssefian
Identity Management:
Focus Design and Marketing
Solutions

Client:
Niq Naq
Nature of Business:
Children's clothing
Design Firm:
Evenson Design Group
Art Director:
Stan Evenson
Designer:
Mark Sojka

Client:
Otis and Claude
Nature of Business:
Dog toy design and manufacture
Design Firm:
Duncan/Channon
Art Director:
Jacquie VanKeuren

Client:
Space Needle
Nature of Business:
Seattle tourist attraction and icon
Design Firm:
Hornall Anderson
Design Works, Inc.
Art Director:
Jack Anderson
Designers:
Mary Hermes, Gretchen Cook,
Andrew Smith, Alan Florsheim,
Cliff Chung, Julie Lock, Holly
Craven, Belinda Bowling,
Elmer De LaCruz
Illustrators:
Andrew Smith, Gretchen Cook

Client:
Scotland Yards
Nature of Business:
Fabric store
Design Firm:
Sibley/Peteet Design
Art Director:
Rex Peteet
Designer:
Rex Peteet
Illustrator:
Rex Peteet

Client:
Cow Parade
Nature of Business:
Art exhibition
Design Firm:
Supon Design Group
Art Director:
Supon Phornirunlit
Designer:
Brent Almond
Illustrator:
Brent Almond

Client:
Cowley County
Community College
Nature of Business:
Art and music festival
Design Firm:
Gardner Design
Art Directors:
Brian Miller, Bill Gardner
Designers:
Brian Miller, Bill Gardner

Client:
Dallas Symphony Derby
Nature of Business:
Horse racing
Design Firm:
RBMM
Designer:
Shazne Washburn

Client:
Estonian Choir
Nature of Business:
Mixed choir
Design Firm:
Telmet Design Associates
Art Director:
Tiit Telmet
Designers:
Tiit Telmet, Melisa Quintos

Client:
Tonamt Frankfurt
Nature of Business:
Sound recording
Design Firm:
FCB Design
Art Director:
Andreas Karl
Designer:
Andreas Karl
Illustrator:
Andreas Karl

Client:
Heartsearch.com
Nature of Business:
Online dating service
Design Firm:
RBMM
Designer:
Dan Birlew

Client:
Open Sesame
Nature of Business:
Internet search engine
Design Firm:
RBMM
Designer:
Matt Staab

Client:
Pulse Systems Inc.
Nature of Business:
Development of medical
management software
and systems
Design Firm:
Insight Design Communications
Art Directors:
Sherrie Holdeman,
Tracy Holdeman
Designers:
Sherrie Holdeman,
Tracy Holdeman
Illustrators:
Sherrie Holdeman,
Tracy Holdeman

Client:
American Cancer Society
Nature of Business:
Non-profit health organization
dedicated to eliminating cancer
Design Firm:
Sayles Graphic Design
Art Director:
John Sayles
Designer:
John Sayles
Illustrator:
John Sayles

Client:
Star Advisors
Nature of Business:
Advice for potential star athletes
Design Firm:
Dotzero Design
Art Directors:
Jon Wippich, Karen Wippich

Client:
Service911.com
Nature of Business:
Online technology support
Design Firm:
Eisenberg And Associates
Art Director:
Megan Webber
Designer:
Megan Webber

Client:
Star Advisors
Nature of Business:
Advice for potential star athletes
Design Firm:
Dotzero Design
Art Directors:
Jon Wippich, Karen Wippich

Client:
Antec
Nature of Business:
Global communications technology
Design Firm:
Wages Design
Art Director:
Bob Wages
Designer:
Matt Taylor

Client:
Kirlin Foundation
Nature of Business:
Advocacy and contributions for
the well-being of children in the
Pacific Northwest
Design Firm:
Methodologie, Inc.
Art Director:
Margo Sepanski
Designers:
Gabe Goldman,
Christopher Downs

Client:
Tai Shin International Bank
Nature of Business:
Banking
Design Firm:
Tong Design
Art Director:
Tong Wai Hang
Designer:
Tong Wai Hang
Illustrator:
Tong Wai Hang

Client:
The Credit Valley Hospital
Nature of Business:
Health care
Design Firm:
The Riordon Design Group
Art Director:
Ric Riordon
Designer:
Dan Wheaton
Illustrator:
Jun Park

GARDENS HAS GROWN.

Client:
Gardens
Nature of Business:
Gardening retail and
landscape design
Design Firm:
Sibley/Peteet Design
Art Directors:
Mark Brinkman, Matt Heck
Designers:
Matt Heck, Mark Brinkman
Illustrator:
Mark Brinkman

GARDENS HAS YOUR HOLIDAYS COVERED. INSIDE AND OUT.

UP TO HALF OFF EVERYTHING AT GARDENS THIS LABOR DAY WEEKEND, AUGUST 28, 29, 30 AND 31.

OUR BULBS ARE IN.

Client:
iAsiaWorks, Inc.
Nature of Business:
Pan-Asian Internet data
center provider
Design Firm:
Gee + Chung Design
Art Director:
Earl Gee
Designers:
Earl Gee, Kay Wu
Illustrators:
Earl Gee, Kay Wu

Client:
Pulsar International
Nature of Business:
Health services
Design Firm:
Signi Design
Art Director:
Daniel Castelao
Designer:
Ventura Albort

Client:
National Association of Home
Builders
Nature of Business:
National trade show for home
remodeling industry
Design Firm:
Kircher
Art Director:
Bruce E. Morgan
Designer:
Bruce E. Morgan

Client:
Zilliant
Nature of Business:
Computer software solutions
Design Firm:
Sibley/Peteet Design
Art Director:
Matt Heck
Designers:
Matt Heck, Ty Taylor
Illustrator:
Rex Peteet

Client:
Chadwick Communications
Nature of Business:
Brand strategy and development
Design Firm:
Chadwick Communications
Art Director:
Chad Chadwick
Designer:
Chad Chadwick
Illustrator:
Don Algeri
CD:
Chad Chadwick

Client:
DSVC Designer's Chili Cook-Off
Nature of Business:
Professional artists' association
Design Firm:
Lambert Design Studio
Art Director:
Christie Lambert Rasmussen
Designer:
Christie Lambert Rasmussen
Illustrator:
Dona Smith

Client:
Glo
Nature of Business:
Skin care
Design Firm:
Design & Image
Art Director:
Tasso Stathopulos
Designer:
Cyndi Gombert
Illustrator:
Tasso Stathopulos

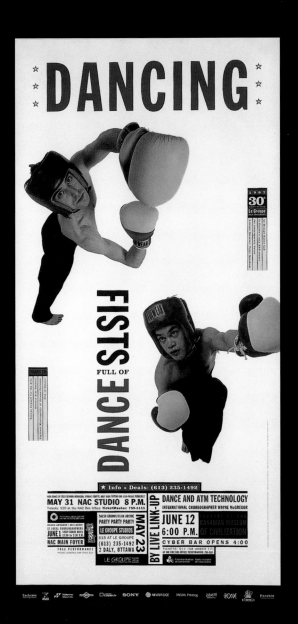

Client:
Le Group Dance Lab
Nature of Business:
Experimental dance event
Design Firm:
Parable Communications
Art Director:
David Craib
Designer:
David Craib
Photographer:
Jim Cochrane

Client:
Storease.com
Nature of Business:
Web-based archives
Design Firm:
Focus Design and Marketing
Solutions
Art Director:
Aram Youssefian
Designer:
Aram Youssefian
Illustrator:
Aram Youssefian
Identity management:
Focus Design and Marketing
Solutions

Client:
Quris
Nature of Business:
Electronic marketing strategy
Design Firm:
Design & Image
Art Director:
Tasso Stathopulos
Designer:
Tasso Stathopulos
Illustrator:
Tasso Stathopulos

Client:
Harcourt Brace Educational
Measurement
Nature of Business:
Educational testing
Design Firm:
Smarteam Communications
Art Director:
Gary Ridley
Designer:
Lisa Carey

Barbara A. Fernandez
Assistant to the President

(512) 344 3020 DIRECT
(512) 397 6602 FAX
barbara.fernandez@the401kcompany.com

Amy Latham
Participant Services Administrator

98 San Jacinto Blvd., Suite 1100
Austin, Texas 78701
(512) 344 3980 (800 THE 401K
(512) 397 6603 FAX
amy.latham@the401kcompany.com

SECURITIES PROVIDED THROUGH 401(K) INVESTMENT SERVICES, INC., MEMBER NASD/SIPC, AN AFFILIATE OF THE 401(K) COMPANY

98 San Jacinto Blvd., Suite 1100 • Austin, Texas 78701 • MAIN (800) THE 401K • FAX (512) 344 3154 • www.the401kcompany.com
SECURITIES PROVIDED THROUGH 401(K) INVESTMENT SERVICES, INC., MEMBER NASD/SIPC, AN AFFILIATE OF THE 401(K) COMPANY

Client:
The 401(k) Company
Nature of Business:
401(k) retirement planning
Design Firm:
Sibley/Peteet Design
Art Director:
Rex Peteet
Designer:
Rex Peteet
Illustrator:
Rex Peteet

153

Client:
University of Calgary
Nature of Business:
Alternative television station
Design Firm:
Brown (Regina)
Art Director:
Erik Norbraten
Designer:
Erik Norbraten

Client:
IRIS Internet
Nature of Business:
Web design
Design Firm:
Eisenberg And Associates
Art Director:
Megan Webber
Designer:
Megan Webber
Illustrator:
Megan Webber

Client:
Kubix Ltd
Nature of Business:
Computer software
Design Firm:
Tor Pettersen & Partners
Art Directors:
Tor Pettersen, David C. Brown,
Nick Kendall
Designers:
David C. Brown, Nick Kendall,
Jim Allsopp

Client:
MEMCO Software
Nature of Business:
Server security
Design Firm:
Sibley/Peteet Design
Art Directors:
Matt Heck, Rex Peteet
Designers:
Matt Heck, Carrie Eko
Illustrator:
Rex Peteet
Copywriters:
Cathy Hill, Dorin Miller

Every company has
information security problems.
MEMCO Software solves them.

MEMCO 1997

MEMCO Software Ltd. 1997 Annual Report

The business world is changing. Commerce is becoming electronic
commerce. Companies are growing more globally dispersed. There
are more "virtual global organizations" than ever. As companies
become distributed and networked communications increase, informa-
tion is accessible to more people – customers, partners, suppliers,
contractors, and employees – than ever before. This changing business
environment is one in which information security breaches are more
common – **and trust is becoming a precious commodity.**

The erosion of trust highlights the need for a new level of information
security. And that means opportunity for MEMCO.

**Why Information
Security is a Problem**

MEMCO Software's solutions are built on the premise that defend-
ing against the threat to information security – no matter how
many forms it takes or industries it affects – comes down to a single,
simple challenge: protecting what a business values the most.
information and business applications. It may be a bank's trading
floor application. Or a company's critical customer database.
Or even a new technology that doesn't yet exist, except in
ideas and diagrams. Data from mission-critical applications and
information can be found on servers in every kind of organiza-
tion, and these servers must be protected.

The question is how to provide the desired increased access
without compromising security. The challenge is to ensure
that key information and applications remain secure – even
when they are more accessible to the customers, partners,
suppliers, and employees who are critical to growing a com-
pany's business. Meeting this challenge is the key to MEMCO
Software's success. MEMCO provides information security
solutions that make access easier for authorized individuals,
while preventing unauthorized access.

Electronic Business Environment
The fundamental challenge presented by the electronic business environment is threefold – to secure enterprise applications, to ensure easy access
for authorized users, and to manage both security and access easily – regardless of how many applications or users are involved.

Users
Customers, Partners, Suppliers, Contractors, Employees

Oracle, SAP, Web, E-Mail, E-Commerce

Client:
EarthLink
Nature of Business:
Internet service provider
Design Firm:
Focus Design and Marketing
Solutions
Art Director:
Aram Youssefian
Designer:
Aram Youssefian
Illustrator:
Aram Youssefian

Client:
Mother Hen Software
Nature of Business:
Golf software development
Design Firm:
Sibley/Peteet Design
Art Director:
Matt Heck
Designers:
David Guillory, Matt Heck
Illustrator:
David Guillory

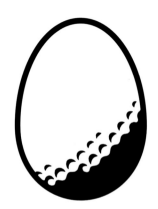

Client:
BigHen Management Ltd
Nature of Business:
Development of Internet
companies
Design Firm:
Letterbox Design
Art Director:
David Hornblow
Designers:
David Hornblow, Simon Cranwell

react

Client:
Kaufman and Broad
Home Corporation
Nature of Business:
Residential real estate
Design Firm:
Louey/Rubino Design Group
Art Director:
Robert Louey
Designers:
Robert Louey, Ashleigh Moses

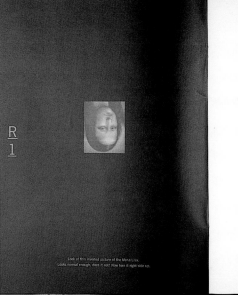

R
1

Look at this inverted picture of the Mona Lisa.
Looks normal enough, does it not? Now turn it right side up.

$4\ 4\ 4\ 4 = 3$

$4\ 4\ 4\ 4 = 6$

$4\ 4\ 4\ 4 = 7$

$4\ 4\ 4\ 4 = 8$

$4\ 4\ 4\ 4 = 24$

$4\ 4\ 4\ 4 = 28$

$4\ 4\ 4\ 4 = 32$

$4\ 4\ 4\ 4 = 48$

Add arithmetical symbols between the 4's to make every equation true.

Client:
First Baptist Academy
Nature of Business:
Christian school
Design Firm:
RBMM
Designer:
Shazne Washburn

Client:
ABBC
Nature of Business:
Armenian church
Design Firm:
Focus Design and Marketing
Solutions
Art Director:
Aram Youssefian
Designer:
Aram Youssefian
Illustrator:
Aram Youssefian

Client:
Christ Church
Nature of Business:
Episcopal church
Design Firm:
Willoughby Design Group
Art Director:
Ann Willoughby
Designer:
Maiko Kuzunishi
Illustrator:
Maiko Kuzunishi

Christ Church
EPISCOPAL

Client:
Shoes for Russian Souls
Nature of Business:
Providing shoes to Russian
orphanages
Design Firm:
Eisenberg And Associates
Art Director:
Cesar Sanchez
Designer:
Cesar Sanchez
Illustrator:
Cesar Sanchez

Client:
Rubin Postaer Direct/Acura
Nature of Business:
Advertising
Design Firm:
Evenson Design Group
Art Director:
Stan Evenson
Designers:
Glenn Sakamoto, Jill Maida

Client:
Richard Lynn's Shoe Market
Nature of Business:
Retail shoe store
Design Firm:
Insight Design Communications
Art Directors:
Sherrie Holdeman,
Tracy Holdeman
Designers:
Sherrie Holdeman,
Tracy Holdeman
Illustrators:
Sherrie Holdeman,
Tracy Holdeman

Client:
Art of Speech
Nature of Business:
Voice recognition technology
Design Firm:
RBMM
Designer:
Horacio Cobos

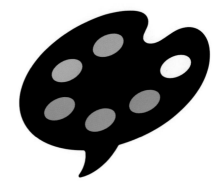

Client:
Fisher
Nature of Business:
Private residence
Design Firm:
Wang/Hutner Design
Art Director:
Maria Wang-Horn
Designer:
Maria Wang-Horn

Client:
Granite Restaurant Group
Nature of Business:
Asian fusion restaurant
Design Firm:
Sibley/Peteet Design
Art Director:
Matt Heck
Designer:
David Guillory
Illustrator:
David Guillory

Client:
VeenendaalCave
Nature of Business:
Interior design
Design Firm:
Belyea
Art Director:
Patricia Belyea
Designer:
Anne Dougherty

Client:
Jazura Entertainment
Nature of Business:
Reggae music production
Design Firm:
The Ablemindz Company
Art Director:
Christopher K. Wright
Designer:
Christopher K. Wright

Client:
City of Pasadena
Nature of Business:
City-sponsored
leadership program
Design Firm:
Focus Design and
Marketing Solutions
Art Director:
Aram Youssefian
Designer:
Aram Youssefian
Illustrator:
Aram Youssefian

Client:
Museum Victoria
Nature of Business:
Museum
Design Firm:
Marcus Lee Design
Art Director:
Marcus Lee
Designer:
George Margaritis

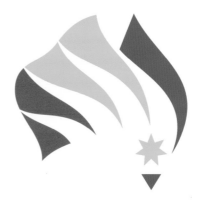

Client:
Tropical Sportswear International
Nature of Business:
Men's and women's
fashion apparel
Design Firm:
Sibley/Peteet Design
Art Directors:
McGarrah, Jessee
Designers:
Matt Heck, Rex Peteet
Illustrator:
Rex Peteet
Photographer:
Dick Patrick
Copywriter:
Doug Irving

Client:
Mandalay Bay Resort & Casino
Nature of Business:
Hotel, resort and casino
Design Firm:
David Carter Design Associates
Art Director:
Lori B. Wilson
Designer:
Sharon LeJeune

Client:
Built2XL
Nature of Business:
Online health and fitness resource
Design Firm:
Supon Design Group
Art Director:
Supon Phornirunlit
Designer:
Todd Metrokin
Illustrator:
Todd Metrokin

Client:
Industria de Refrigerantes Caxias
Nature of Business:
Beverage production
and distribution
Design Firm:
Porto & Martinez Design Studio
Art Directors:
Bruno Porto, Marcelo Martinez
Designers:
Marcelo Martinez, Bruno Porto

Client:
Jester Insurance
Nature of Business:
Insurance
Design Firm:
Sayles Graphic Design
Art Director:
John Sayles
Designer:
John Sayles
Illustrator:
John Sayles

Client:
Museum Victoria
Nature of Business:
Museum
Design Firm:
Marcus Lee Design
Art Director:
Marcus Lee
Designer:
George Margaritis

Client:
Danish Design
Nature of Business:
Scandinavian furniture import
Design Firm:
Jensen Design Associates
Art Director:
David Jensen
Designer:
David Jensen

Client:
Youth Development Foundation
Nature of Business:
Foundation for youth development
Design Firm:
Tong Design
Art Director:
Tong Wai Hang
Designer:
Tong Wai Hang
Illustrator:
Tong Wai Hang

Client:
Rowland McKinney
Nature of Business:
Internet solutions brokerage
Design Firm:
Walker Creative, Inc.
Art Directors:
Tim Walker, Daniel Bertalotto
Designer:
Daniel Bertalotto

Client:
Dr. Dangstorp
Nature of Business:
Dentistry
Design Firm:
Bradbury Design Inc.
Art Director:
Catharine Bradbury
Designer:
Bradbury Design Inc.

Client:
Dr. Georg Leitl
Nature of Business:
Heart surgery
Design Firm:
Marcus Lee Design
Art Director:
Marcus Lee
Designer:
George Margaritis

Client:
Homewood Corporation
Nature of Business:
Health care
Design Firm:
The Riordon Design Group
Art Director:
Ric Riordon
Designer:
Dan Wheaton
Illustrator:
Sharon Porter

Client:
Aspen Traders
Nature of Business:
Women's clothing
Design Firm:
Gardner Design
Art Director:
Brian Miller
Designer:
Brian Miller

Client:
Art Center College of Design
Alumni Council
Nature of Business:
Alumni association
Design Firm:
Gee + Chung Design
Art Director:
Earl Gee
Designer:
Earl Gee
Illustrator:
Earl Gee

Client:
EFG Companies
Nature of Business:
Auto industry sales and service
Design Firm:
Peterson & Company
Art Director:
Nhan Pham
Designer:
Nhan Pham
Illustrator:
Nhan Pham

Client:
Sunset Blvd.
Nature of Business:
Tanning salon
Design Firm:
Brown Communications Group
Art Director:
Dave Gowryluk
Designer:
Morris Antosh

Client:
XYZ Productions
Nature of Business:
Multimedia production
Design Firm:
Frank D'Astolfo Design
Art Director:
Frank D'Astolfo
Designer:
Frank D'Astolfo

BOULLIOUN

Client:
Boullioun Aviation Services
Nature of Business:
Aircraft leasing
Design Firm:
Hornall Anderson Design
Works, Inc.
Art Directors:
Jack Anderson, Katha Dalton
Designers:
Katha Dalton, Ryan Wilkerson,
Belinda Bowling

Client:
Food Marketing Institute
Nature of Business:
National trade show
Design Firm:
Kircher
Art Director:
Bruce E. Morgan
Designer:
Bruce E. Morgan

Client:
Arbor Tech
Nature of Business:
Landscape design
Design Firm:
RBMM
Designer:
Dan Birlew

Client:
Polarity
Nature of Business:
Public relations
Design Firm:
Marcus Lee Design
Art Director:
Marcus Lee
Designer:
Shane Hurt

Client:
Power Computing/Sicola Martin
Nature of Business:
Computer manufacture
Design Firm:
John Evans Design
Art Directors:
John Evans, Didi Stuart
Designer:
John Evans
Illustrator:
John Evans

Client:
Hammerquist & Halverson
Nature of Business:
Advertising
Design Firm:
Hornall Anderson Design
Works, Inc
Art Director:
Jack Anderson
Designer:
Mike Calkins
Illustrator:
Mike Calkins

INDEX BY CLIENT

INDEX BY CLIENT